ABANDONED MARYLAND

EASTERN SHORE

CAROL BARDZELL

AMERICA
THROUGH TIME®
ADDING COLOR TO AMERICAN HISTORY

America Through Time is an imprint of Fonthill Media LLC
www.through-time.com
office@through-time.com

Published by Arcadia Publishing by arrangement with Fonthill Media LLC
For all general information, please contact Arcadia Publishing:
Telephone: 843-853-2070
Fax: 843-853-0044
E-mail: sales@arcadiapublishing.com
For customer service and orders:
Toll-Free 1-888-313-2665

www.arcadiapublishing.com

First published 2021

ISBN 978-1-63499-327-2

Typeset in Trade Gothic
Printed and bound in England

CONTENTS

ABOUT THE AUTHOR

Originally from Connecticut, Carol Bardzell received her BFA in photography from Montserrat College of Art in 2011. After her first couple of visits to Maryland, she found interest in the vast amount of abandoned properties and farmland. Having always been fascinated by abandoned structures, what's left behind, and how nature takes back these places, she decided the Eastern Shore of Maryland would be the perfect location for her senior seminar project. Today, Carol resides on the Eastern Shore of Maryland with her husband and two cats.

INTRODUCTION

Most of this book was shot back in 2010-2011 when I had been shooting specifically for my senior seminar project in college. That senior seminar project grew out of my first trip to Snow Hill, Maryland, an area of flat land, scattered with decaying businesses and deserted farmlands. Fascinated with a radically different landscape than the residential area of Connecticut I'd grown up, I was inspired to document the way light interacts with uninhibited, crumbling structures. I was also concerned with the lines and shapes formed by the disregarded objects and the remains of these buildings.

From the original photographing I created a much smaller version of this book that only consisted of thirty-eight images and did not include all the locations found in this book. I was thrilled when given the opportunity to expand on this project. When contacted about creating this book, I finally found a reason to shoot some of the places I had always wanted to photograph.

After my initial visit, I drove the eight hours from Massachusetts to Maryland about once a month in order to explore these deserted structures. Inside and around these sites, I found strong light sources that accentuated the process of manmade structures decomposing back into nature. The compositions of these photographs are made up of lines created by discarded objects and the remains of these structures. In capturing these compositions in photographs, it is my intention to make obvious the visual elegance that otherwise goes unnoticed. I am moved to respond to the fact this beauty exists even when no one is there to see it.

When photographing abandoned landscapes, I like to capture how nature now interacts with these manmade buildings. I love seeing how nature comes in and takes back the land, and how it creates interesting lines between both nature and

manmade. Whenever I go into these properties, I always wonder what life event happened that left these places abandoned and why the owners left so much behind.

Upon graduating from college, I moved to Maryland and found it was hard to drive anywhere without finding an abandoned structure of some sort. I also found that sometimes it was difficult to tell if a property was actually abandoned or not. After driving by properties I thought were abandoned on multiple days at different times, I would sometimes discover that vehicles were coming and going and someone actually lived there.

Whenever I went to shoot a location, I preferred to go with someone else. If I was only shooting the exterior of building, I would go alone, but if I was going inside, I took someone with me. Many of these buildings were so decayed, I had to be very careful not to fall through a floor or a ceiling. I felt safer knowing that there was someone else there in case one of us got hurt. With some of the photos, I even needed that person there to hold on and to support me while I got the angle I wanted for a shot. There was a bit of a risk going into these houses, because of the decay and the fact that I never received permission to enter any of the buildings photographed in this book.

Many of these properties I just happened to stumble upon during my daily ongoings, but when I began this project, I started researching additional locations to include in this book in addition to the ones I already shot in college. During this research, I found an online program called Medusa, provided by the Maryland Historical Trust, that shows you a map with all the historical landmarks located across Maryland. Many of the locations provide a PDF file that gives you the history of property as far back as the Maryland Historical Trust has been able to discover. To my surprise, locations I had already shot were included and have a very rich history about the beginnings of the Eastern Shore.

1

SNOW HILL, MARYLAND

This property was shown to me back in 2011 when I had been shooting abandoned properties for my senior seminar project. We had taken many backroads to get there, and I'm not sure that I would be able to find this property again today. That is if the property even still exists today, as many of the properties I had shot for my original project have since been torn down. The Eastern Shore of Maryland is filled with many abandoned houses and farmlands. It is rare to take a drive somewhere and not find a house that has been abandoned and taken back by nature.

Many properties on the Eastern Shore of Maryland are much like this one. Many people have a house or trailer on a plot of land with one or more poultry houses located towards the back of the property. Chicken is a big business on the Eastern Shore, and it is a typical sight to see trucks driving by, loaded up with chickens heading to Purdue or Tyson. It is also not uncommon for these types of properties to also grow corn or soybeans on the surrounding lands.

I loved this property because there was so much to explore. Not only was there a trailer that was once a family's home, but many sheds and barns filled with all sorts of farming equipment and personal items, giving you a glimpse into the lives of the family who had once lived there. One of the largest structures was a two-story poultry house with a design has not been used in the poultry industry in over thirty years. Though the barn is now completely empty of chickens, remnants of their existence can still be seen where cooling fans and feeding pipes remain.

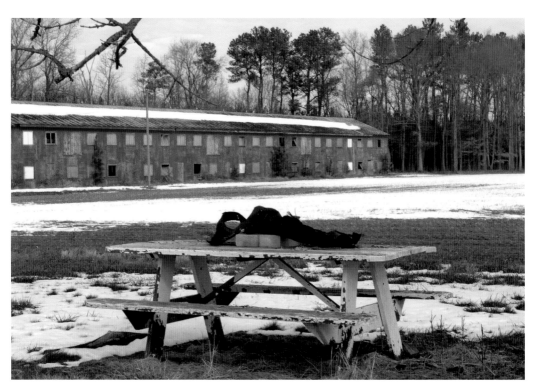

Picnic table with a destroyed tire in front of the chicken house, which can be seen from the kitchen window in trailer.

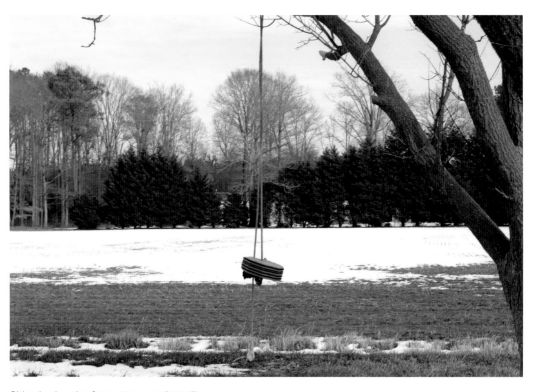

Old swing hanging from a tree near the trailer.

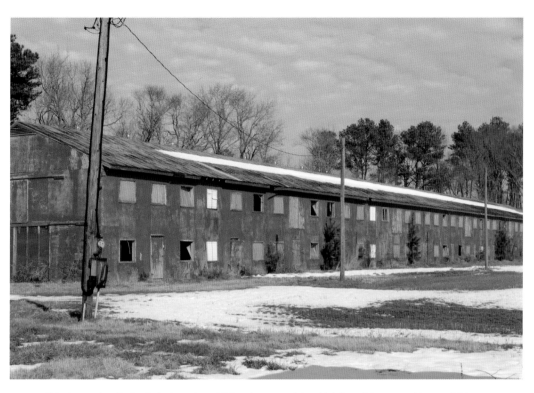

Telephone wires in front of a two-story chicken house, a style which hasn't been used in over thirty years.

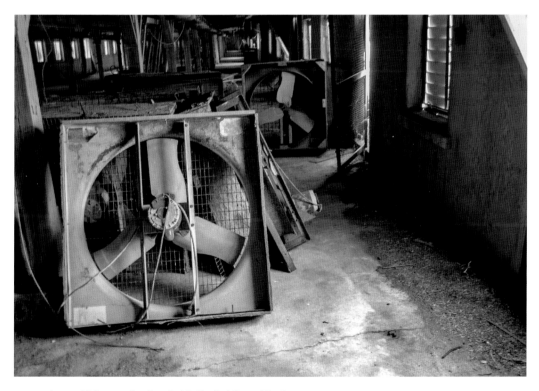

Large chicken cooling fans inside the first floor of the barn.

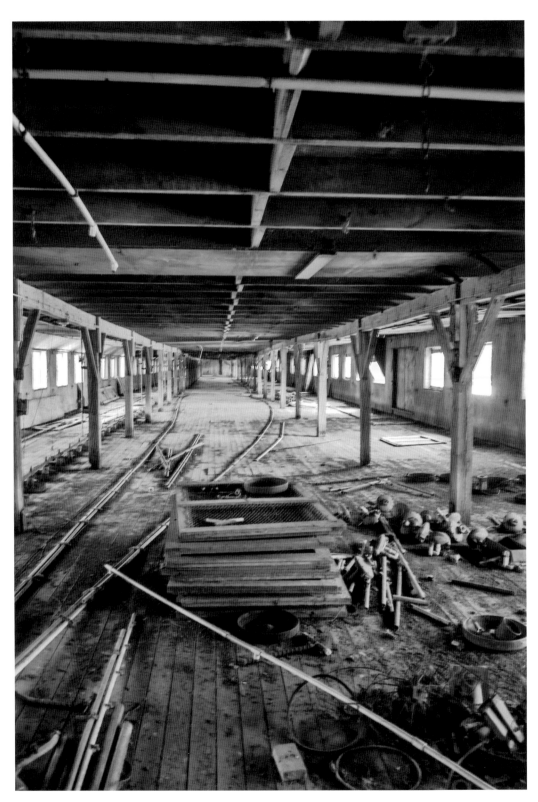

Second floor of the barn with feeding pipes running along the length of the barn.

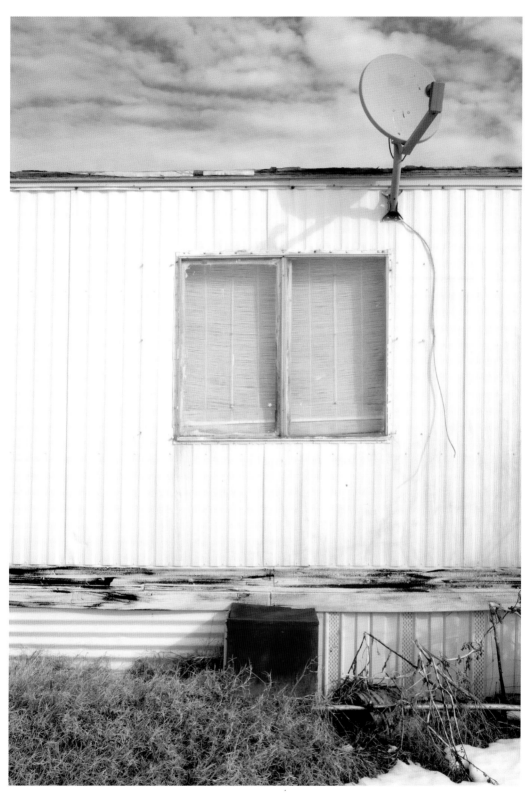

Side view of the trailer with a satellite dish on top.

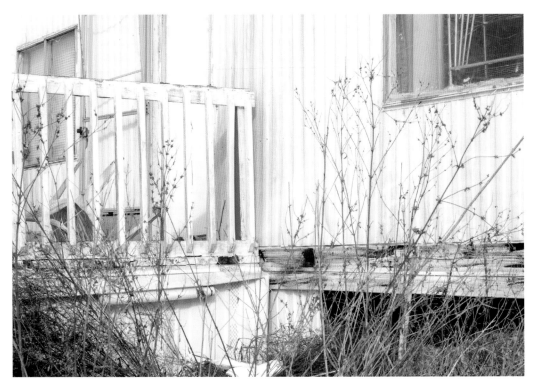

Close up of the railing to the entrance of the trailer with plant overgrowth.

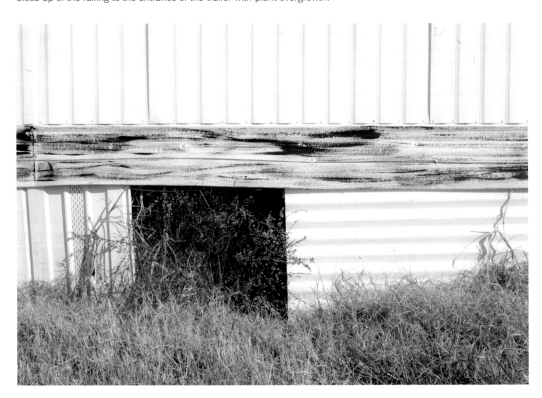

Missing skirting from the bottom of the trailer.

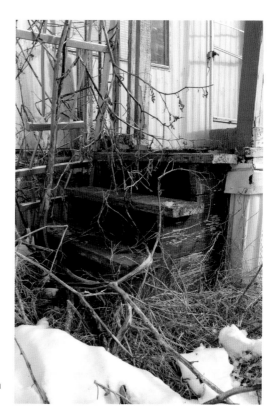

Stairs to the entrance of the trailer with overgrown vines and broken trellis.

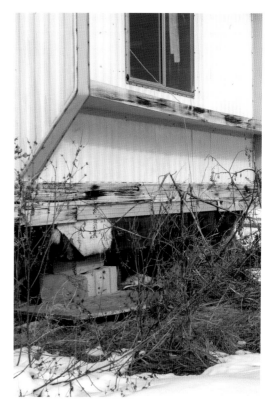

Concrete slabs supporting the front of the trailer.

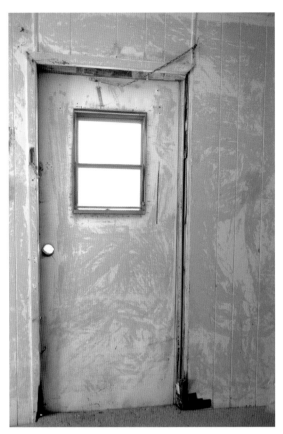

Left: Door to exit the back of the trailer with a missing doorknob.

Below: Santa Fe cigarette buds on the toilet shelving.

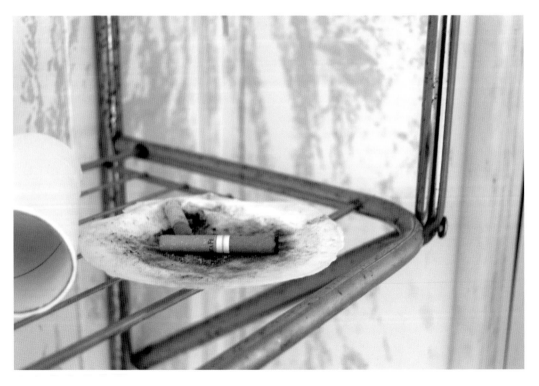

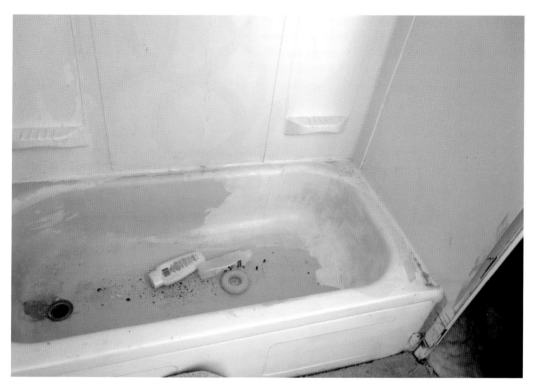

Shampoo bottles and children's toy in the bottom of the bathtub.

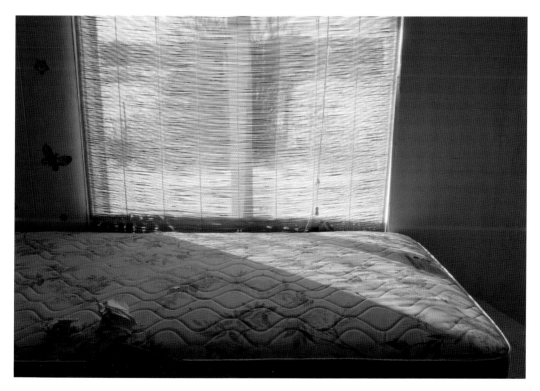

Blinds and a twin mattress in a child's bedroom.

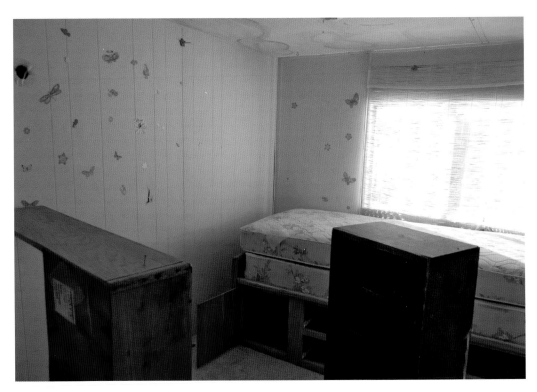

Stickers on the pink wall of a child's bedroom.

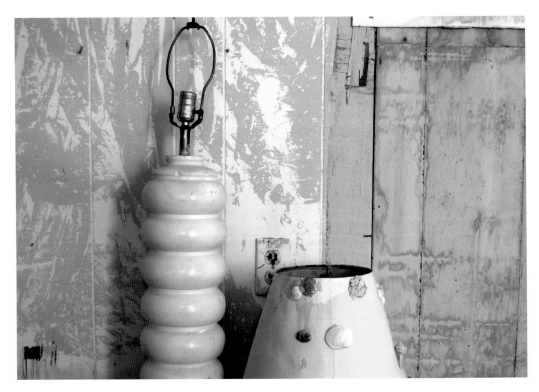

Lamp with the shade removed, decorated with seashells, on the floor of the living room.

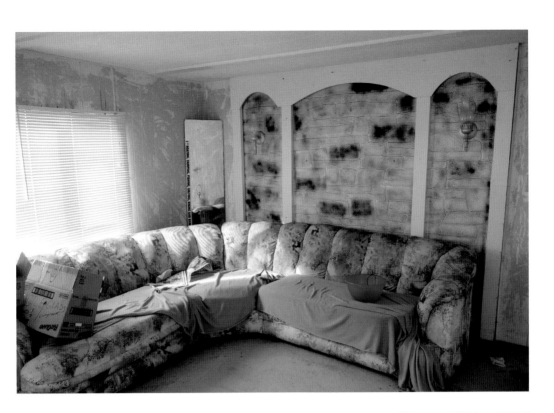

Above: Decaying wrap-around couch in the living room across from the kitchen.

Right: Framed art with school portraits attached to the frame, located in the kitchen.

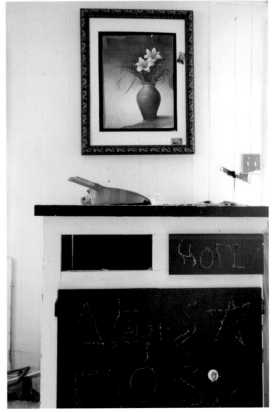

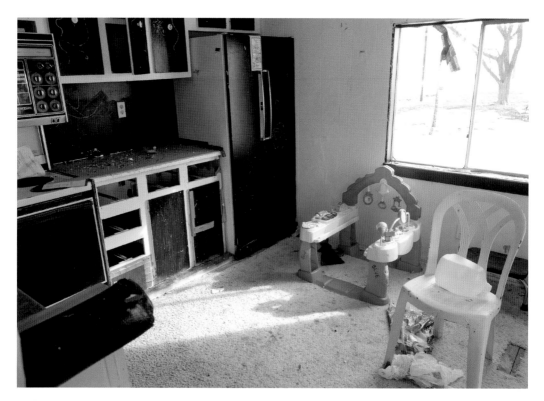

Kitchen with a baby play set under window.

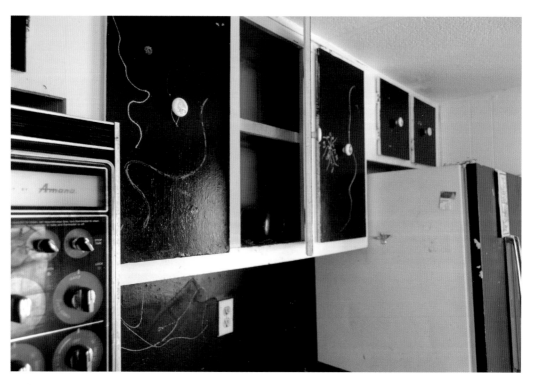

Kitchen cabinets with chalk scribbles and princess knobs.

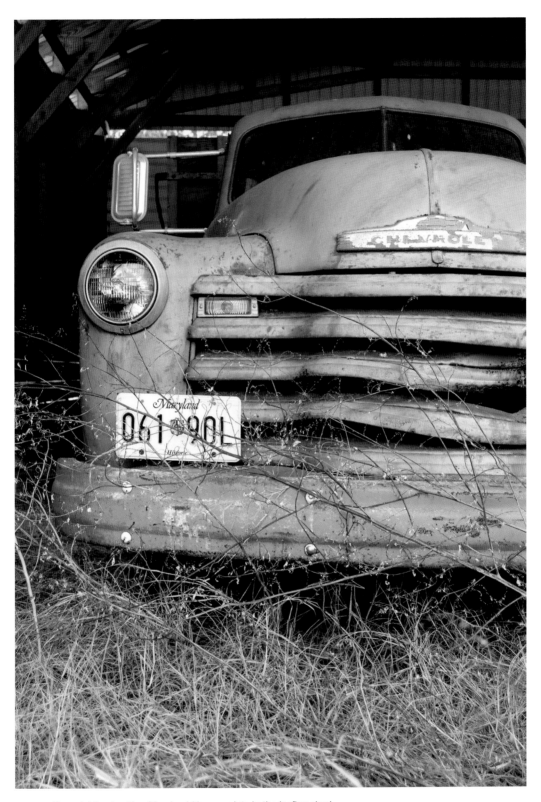

Chevrolet truck with a Maryland License plate in the loafing shed.

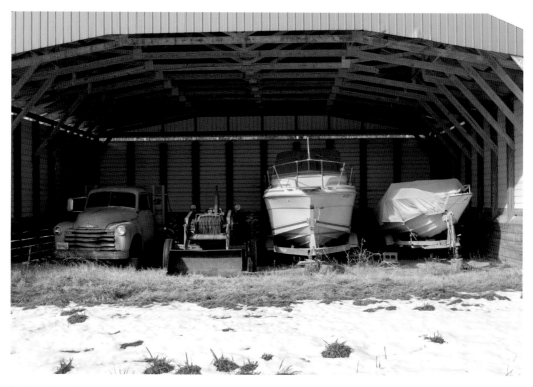

Loafing shed with a truck, tractor, and boats located behind the trailer.

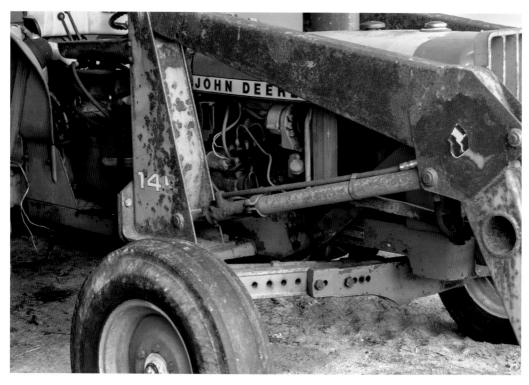

Close up of a John Deer tractor located in the loafing shed.

Right: Discarded paint bucket in front of the lean-to.

Below: Close up of the dented fender of a Chevrolet truck.

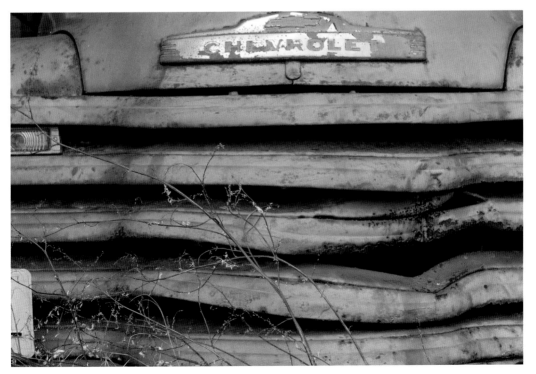

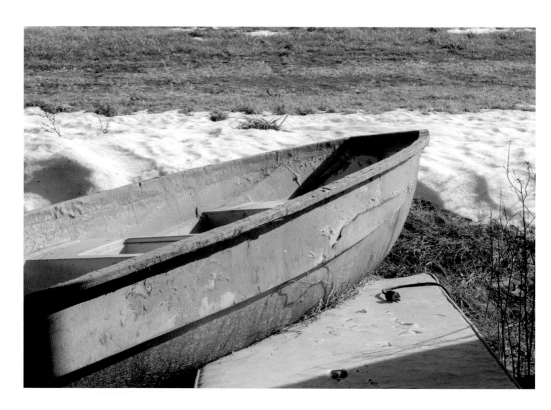

Above: Rusting motorboat on top of a torn mattress near the loafing shed.

Left: Painting, wire, and paint buckets under the lean-to.

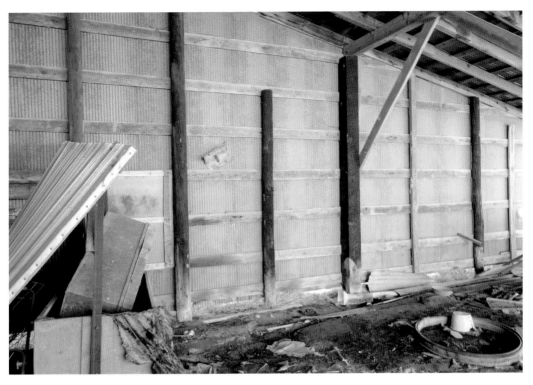

Discarded trash under the lean-to, located behind the trailer.

Close up of rotting wood of the fallen roof near the lean-to.

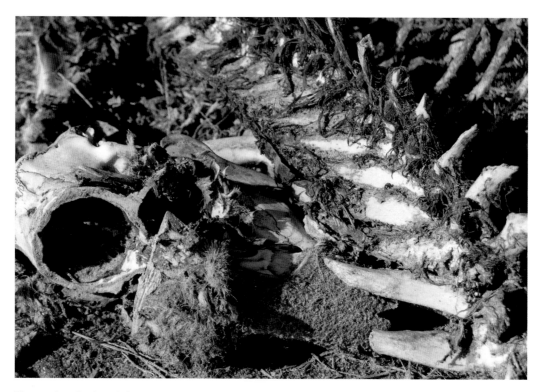

The remains of a deer skeleton outside of the lean-to.

Drawer liner of a desk located near a deer skeleton.

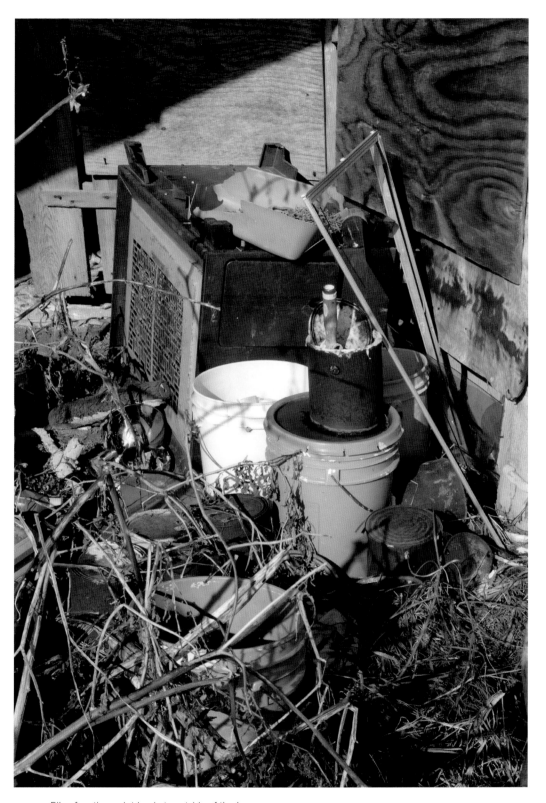

Pile of rusting paint buckets outside of the barn.

2

THE HARRY CHERRIX FARMHOUSE

The property known as the Harry Cherrix Farmhouse has an interesting history. It can be found on the east side of Snow Hill Road, also known as MD 12. The property consists of a farmhouse, meat house, square side-gable house stable, corncrib, and concrete block machine shed.

Built *circa* 1850, this farmhouse was built by Charlotte J. (Dennis) Hack on land inherited by her father, Captain James Dennis, on November 27, 1848. In 1668, it had been patented as "Mardike" to Captain Paul Marsh, then comprising of 1,000 acres. This land was bought and sold many times over the years and it is unknown how Captain James Dennis originally acquired the land.

It is one of two farmsteads that resides on a total of 370 acres of land. This original farmhouse is on 170 abandoned acres, while the other farmhouse resides on 200 acres and is currently occupied.

The Cherrix family came to own this property in 1903 when they purchased it from Jacob Frederick Wooley. The land surrounding this property is still used for farming to this day, though the house remains deteriorating. The original farmstead is known as the Harry Cherrix Farmhouse, while the newer occupied farmstead is known as the Ruth Cherrix Farmhouse.

The Harry Cherrix property is an L-shaped house with three chimneys, two floors, and an attic. At the time this property was built, Worcester County was thinly populated, with only 16,730 people residing there. Today, over 52,000 people live in Worcester County. Most likely the farmland surrounding this house had been used to grow tobacco until the second and third decades of the nineteenth century when major changes happened with the farming industry.

I drove by every day on my way to an internship for a good portion of year before finally deciding to find someone to go with me to photograph it. It was well worth the wait. While exploring, I had to be extremely careful because the ceilings and floors were falling in throughout many parts of the house and outbuildings. It wasn't until I started researching more properties to photograph for this book that I realized that it was called the Harry Cherrix Farmhouse and had interesting history attached to it.

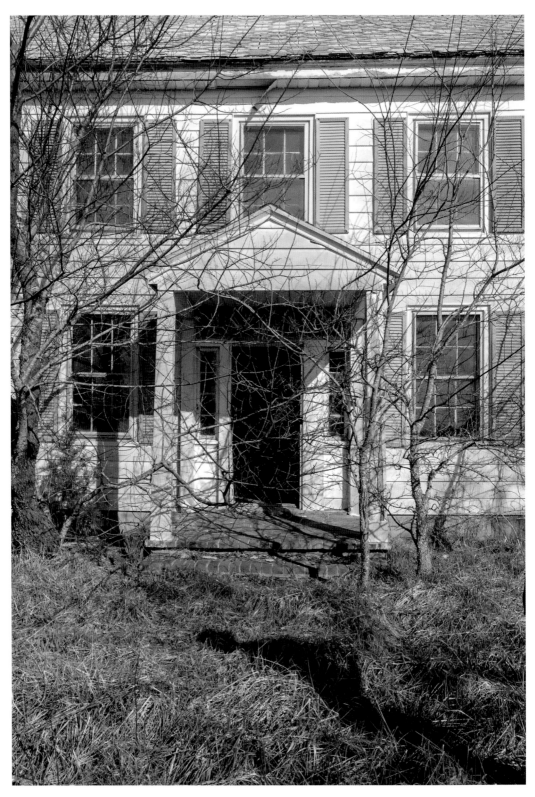

Front entrance of the Harry Cherrix Farmhouse.

Right: Yellow dump truck partially buried in the side yard.

Below: Windows in what I assume was the living room.

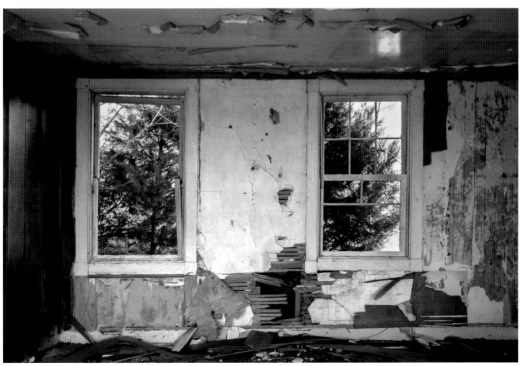

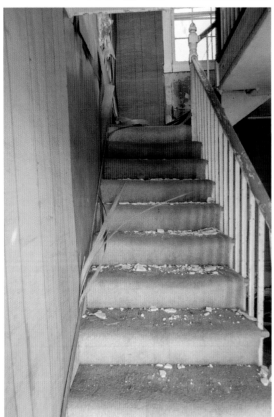

Above: Peeling ceiling paint in the living room.

Left: Stairs going to the second floor up from the front door.

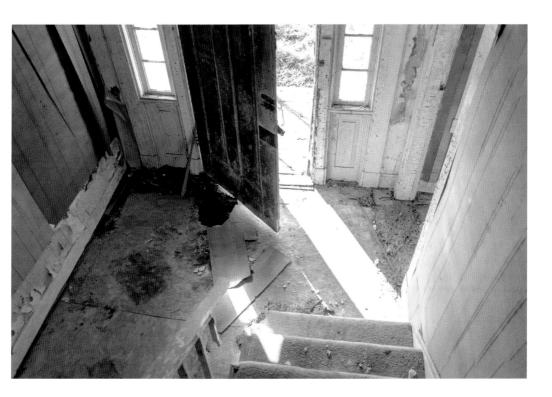

Above: Looking down the main stairs to the front door.

Right: Stairs leading upstairs from the kitchen.

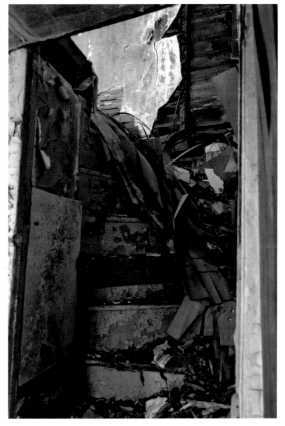

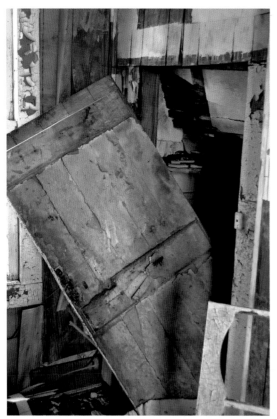

Left: Broken door of the kitchen pantry.

Below: Kitchen counter and cabinets.

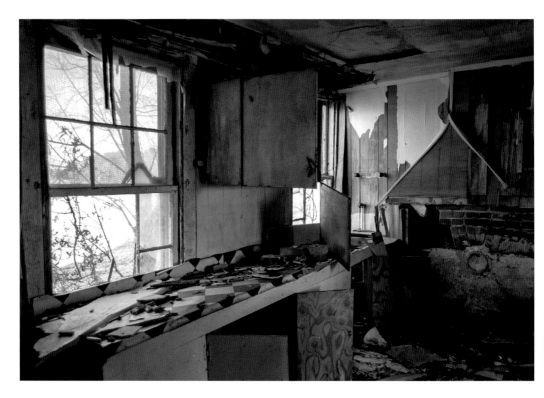

Above: Floor of the kitchen with fallen drywall.

Right: Broken back door in the kitchen, leading outside.

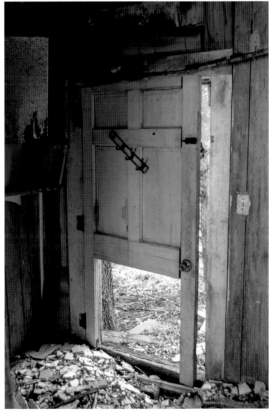

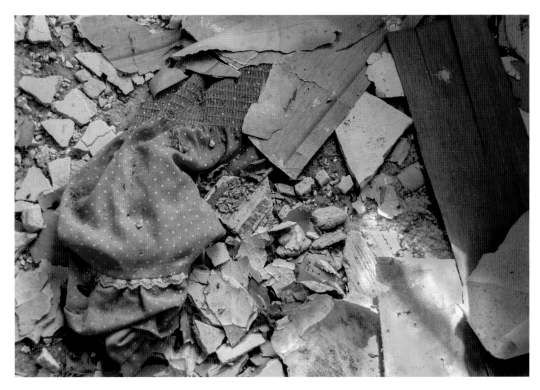

Little girl's red dress in fallen rubble.

Fallen wall and ceiling rubble located on the second-floor landing.

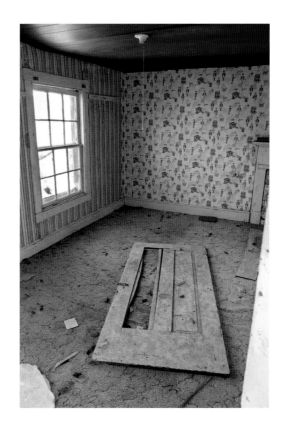

Fallen broken door of a bedroom, located on the second floor.

Peeling confederate wallpaper.

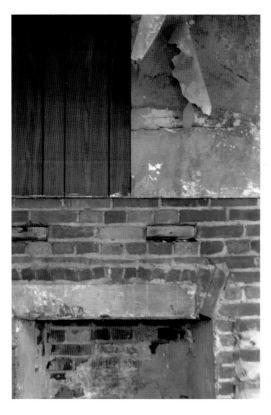

Crumbling chimney and wall on the second floor of the house.

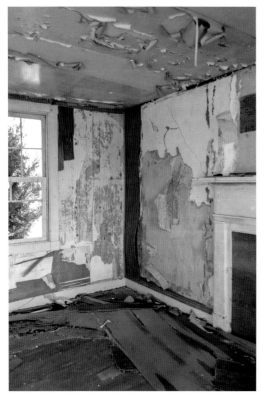

Orange paint showing under a peeling wall.

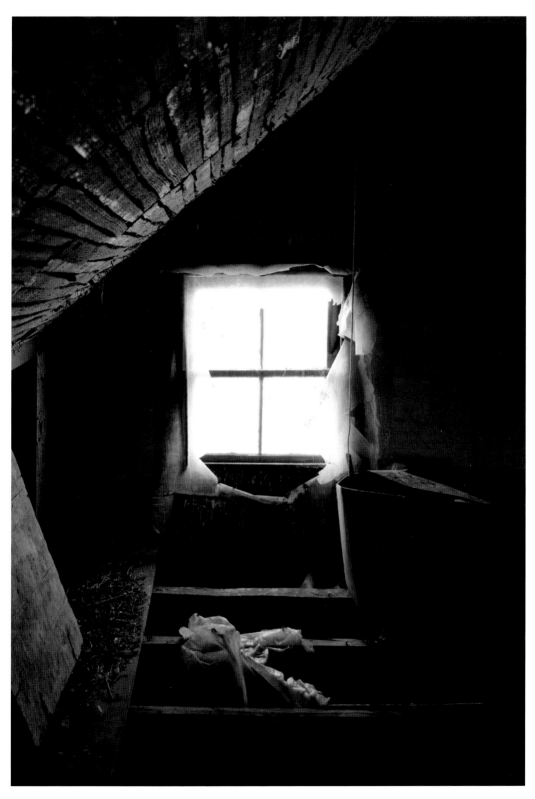

Attic window.

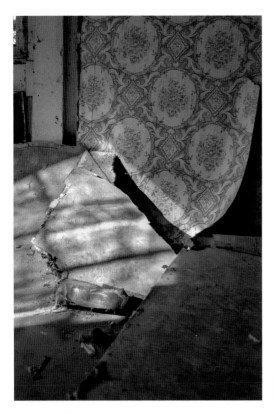

Peeling wallpaper and fallen drywall from a bedroom on the second floor.

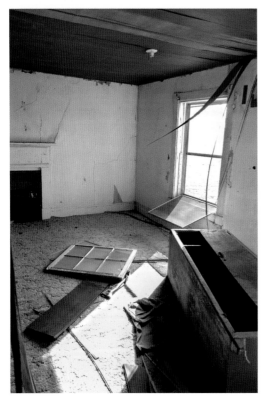

Fallen wardrobe in a bedroom.

Broken window in a pile of pine needles and shingles.

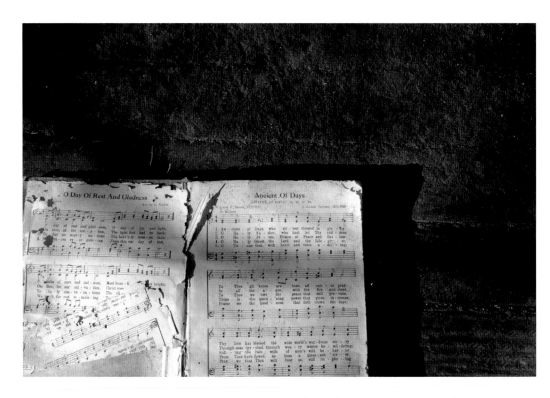

Above: Church music book on the floor of the barn behind the house.

Left: Random shoes on the floor of the barn.

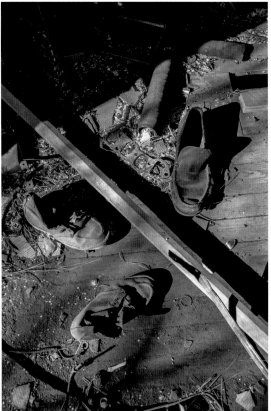

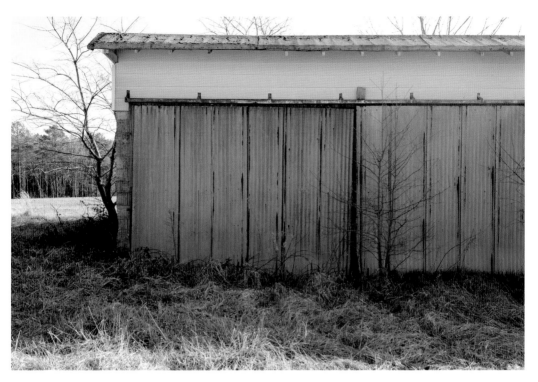

Metal sliding doors to the shed located behind the house.

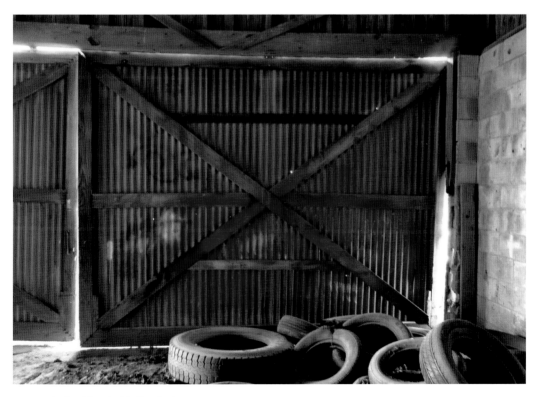

A pile of tires inside the shed.

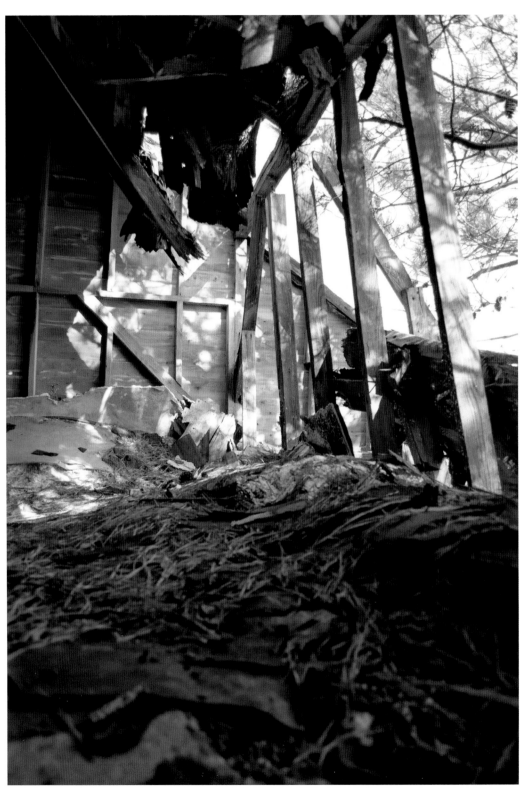

Caved-in roof of the barn's second floor.

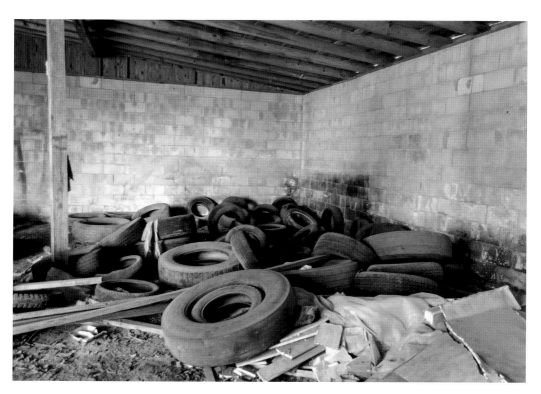

More discarded tires in a concrete block machine shed.

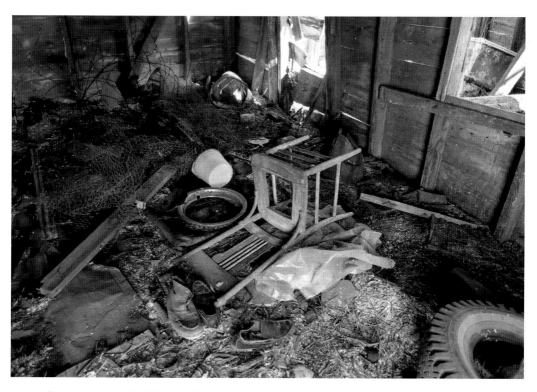

Green chair on a pile of discarded items located in the barn.

3

THE CAHALL'S PROPERTY

This property I happen to stumble upon in 2011 after dropping my car off for repairs. It had so much to explore that I spent a few hours shooting. It had a farmhouse, sheds, a garage and many other buildings filled with all sorts of objects long forgotten about.

I started with exploring the main house, finding many of the first-floor rooms covered in graffiti. On the second floor I found many toys, electronics, and holiday decorations scattered all over the floors, requiring caution with my steps. Once outside to explore the outbuildings, I found a lot of the same—toys, furniture, clothes, and more scattered about, filling the property with remnants of the past.

The house was originally built in 1930 and was on 102.15 acres of farmland. I was not able to find much about the family living here before it was abandoned, or much about the history of the property. The house that stood on the property was two stories, with one bathroom, and only 1,288 square feet. If you were to go looking for it today, you would be unable to find it. From what I've been able to gather since I shot it, it was torn down about a year later and is now all farmland.

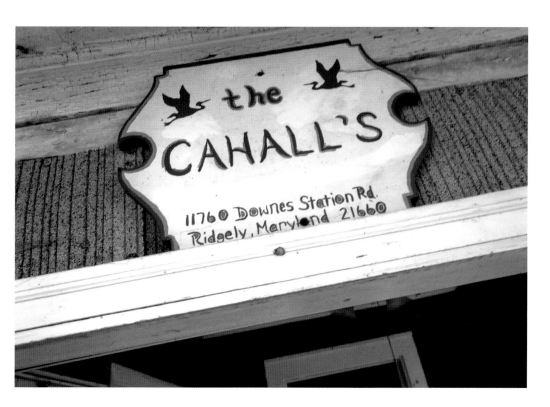

Above: The Cahall's wooden sign located above the entrance to the house.

Right: Front door of the Cahall's property with overgrown trees.

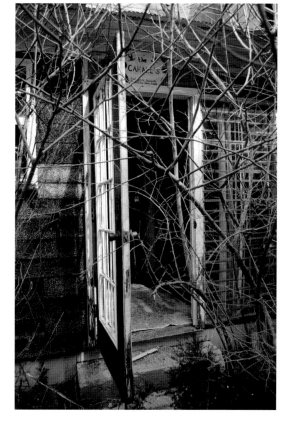

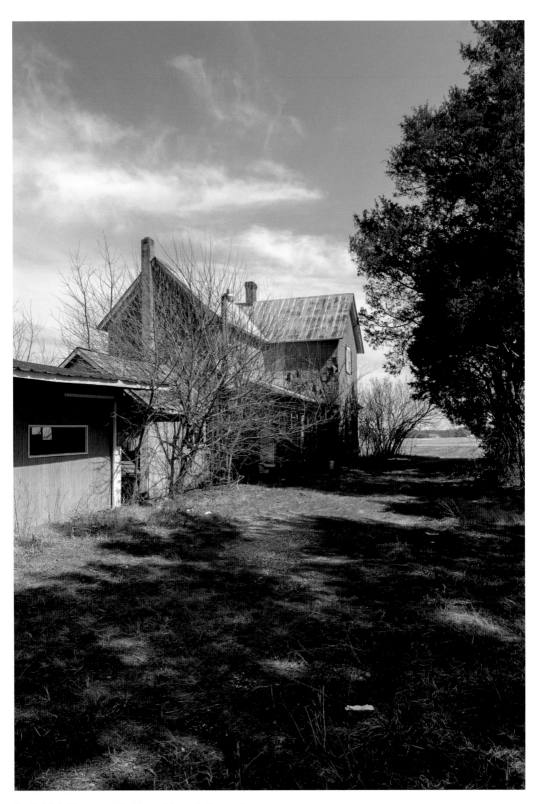

Yard of Cahall's property looking out towards the road.

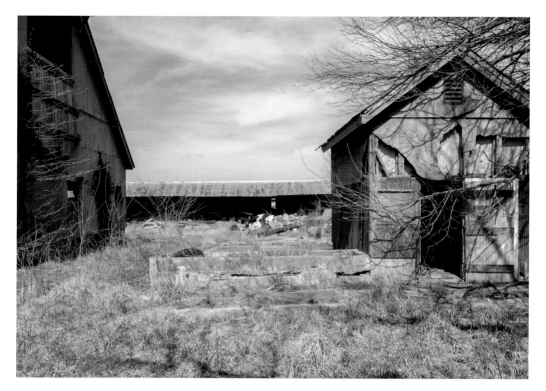

Shed and barn located behind the main house.

Close up of tree in front of the shed door.

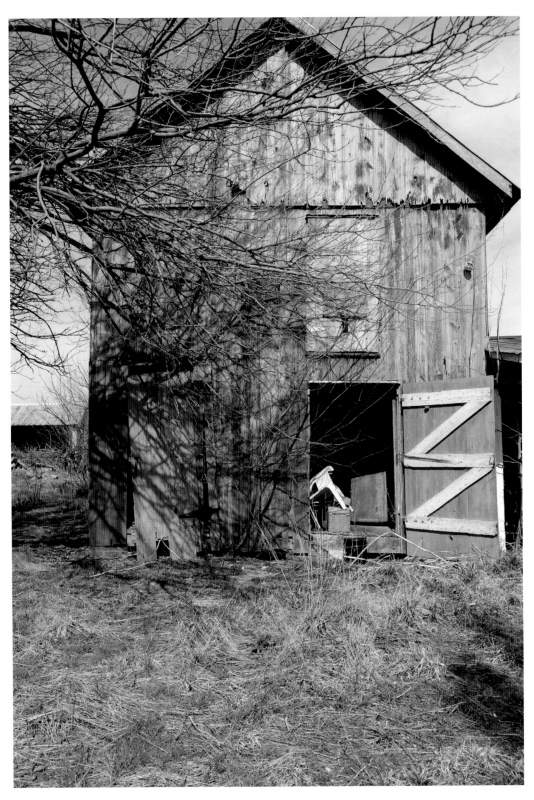

A storage shed attached to the lean-to.

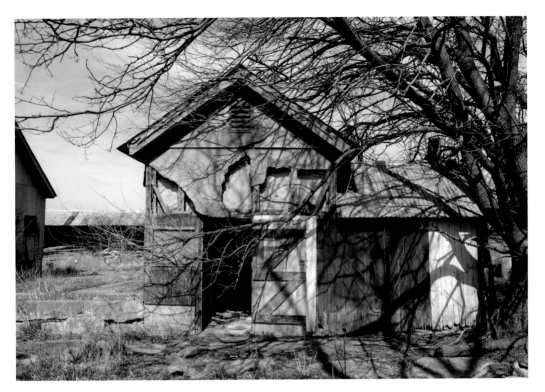

Front of an additional storage shed.

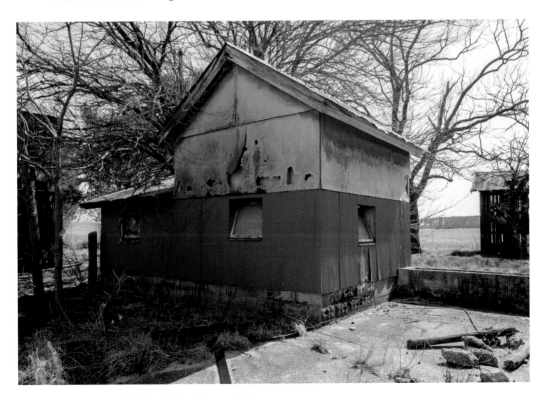

View of the back of the additional storage shed.

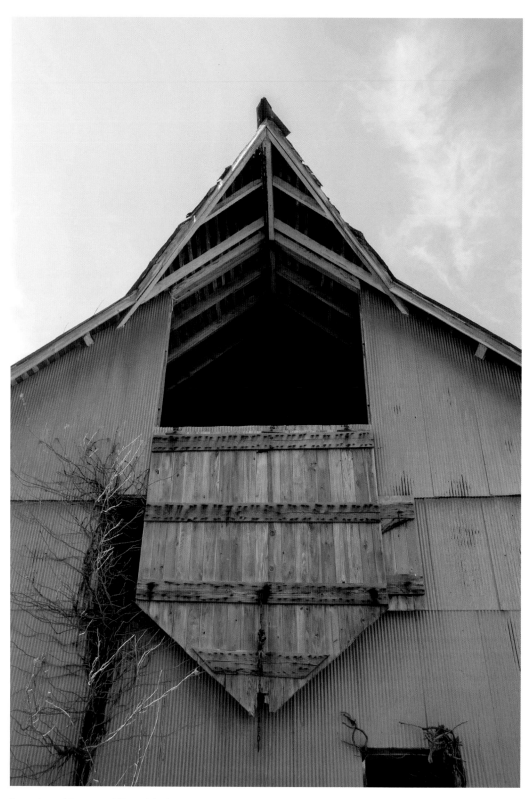

Open door of the second floor of the barn.

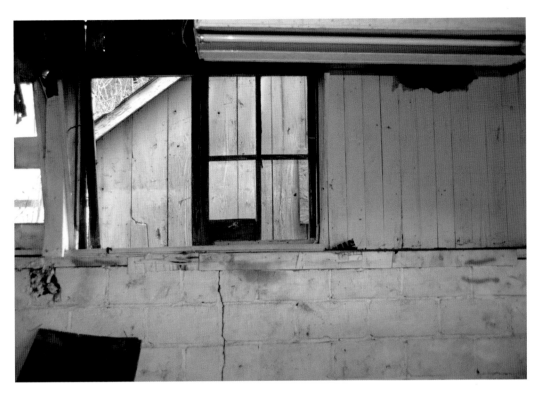

Open broken window in one of the sheds.

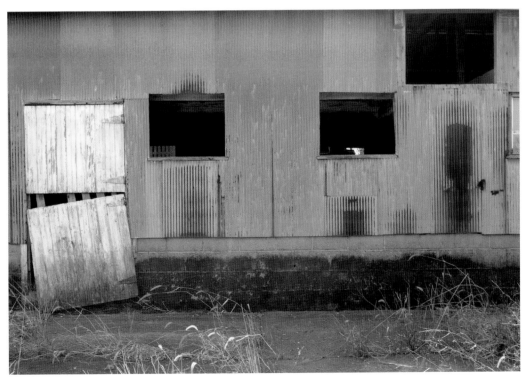

Broken first floor door to the barn.

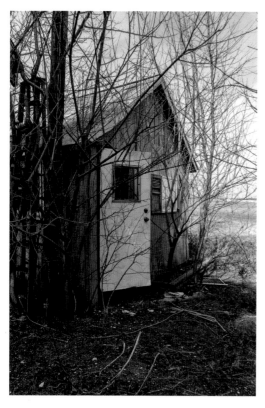

Front of a third storage shed.

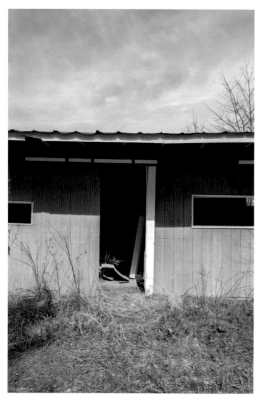

Entrance to the garage.

Broken doors, drywall, a tire, and a bottle located between the sheds.

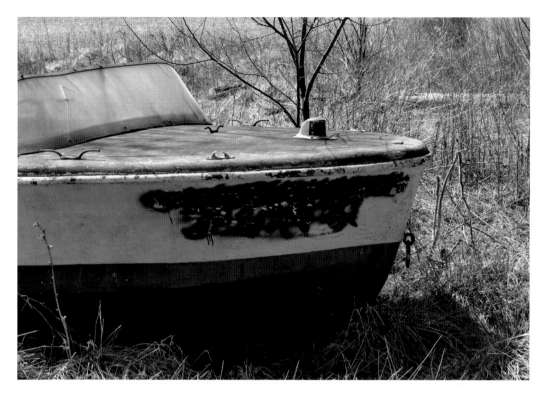

Boat with blacked-out graffiti siting out in the yard.

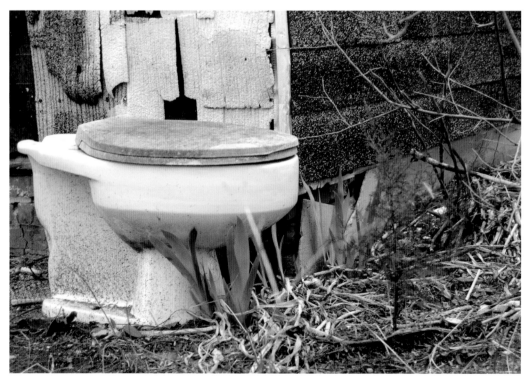

Toilet sitting at the corner of the main house.

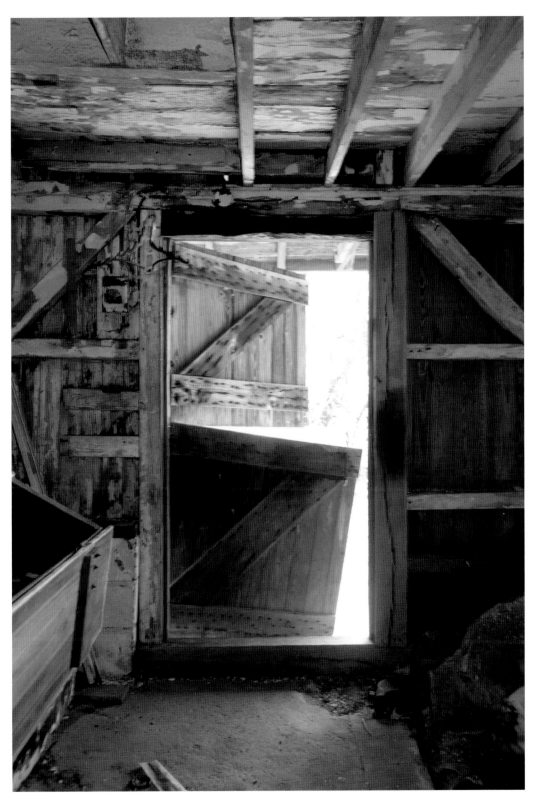

Inside view of the broken barn door.

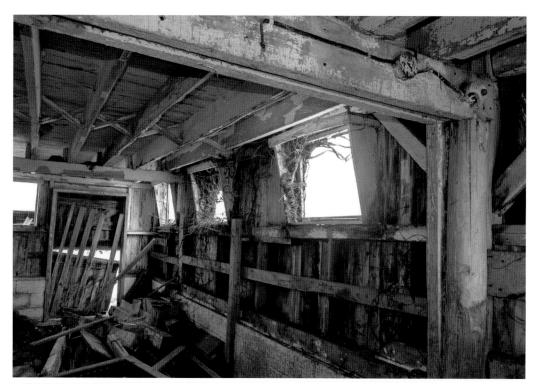

Vines growing on windows inside of the barn.

Vines growing on the barn wall.

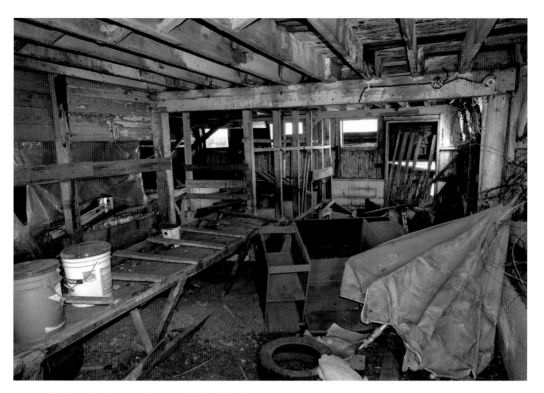

Table umbrella and paint cans inside of the barn.

Interior shot of one of the sheds.

Window cut in the wall of the garage.

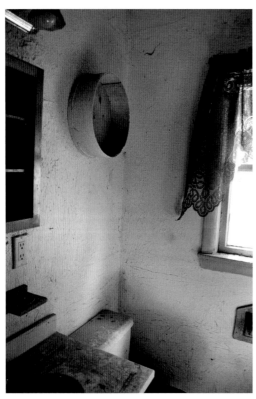

View of the wall in the bathroom next to the toilet.

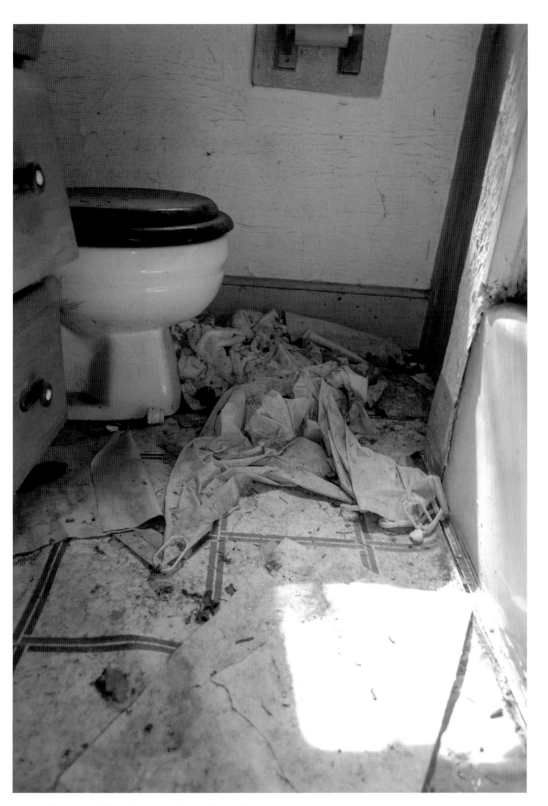

Shower curtain and towels on the bathroom floor.

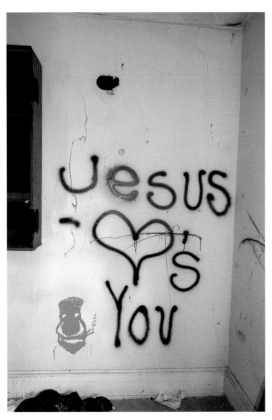

Left: Jesus loves you graffiti located in the living room.

Below: Steve M graffiti located in the kitchen.

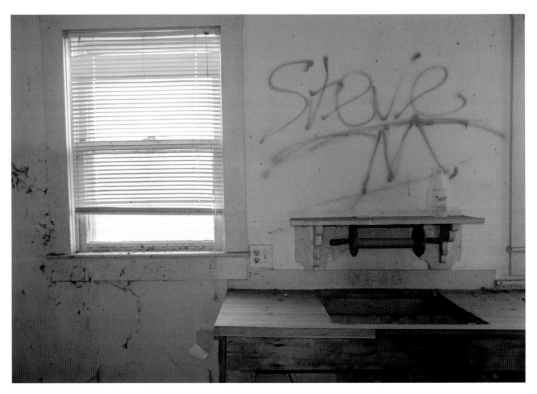

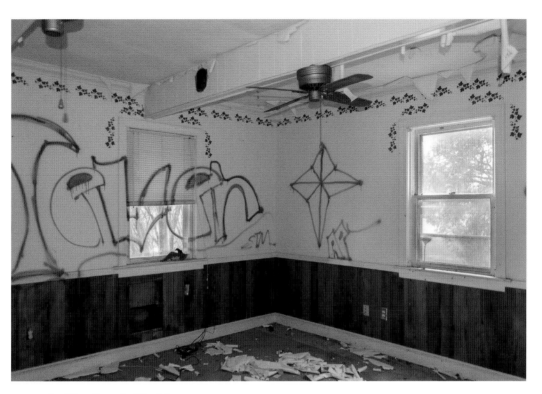

Graffiti on the wall of the living room.

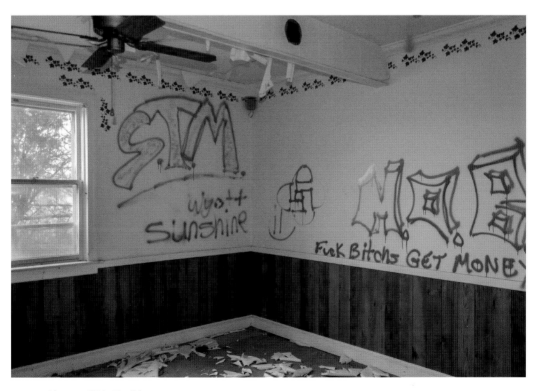

More graffiti in the living room.

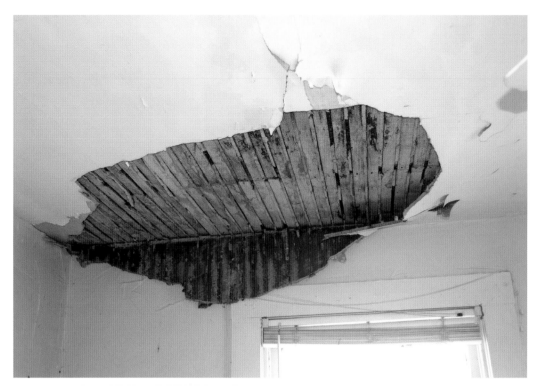

Torn ceiling in a child's bedroom on the second floor.

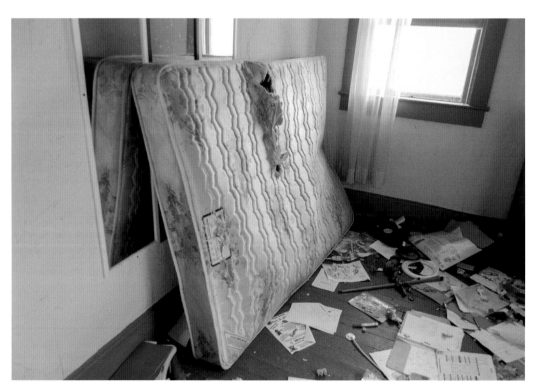

Mattress leaned against the wall in a child's bedroom on the second floor.

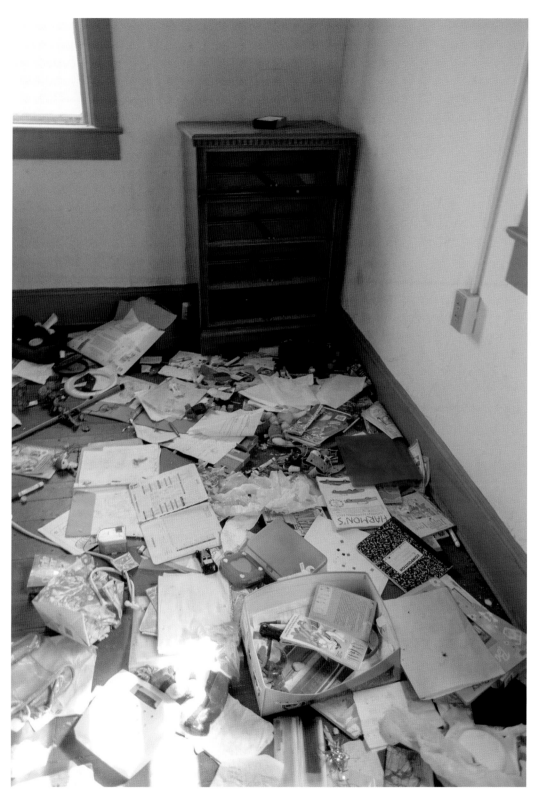

Discarded schoolwork on the floor of a child's bedroom.

4

POWELLVILLE, MARYLAND

T he beginnings of Powellville, Maryland, started in the early nineteenth century, when a village formed around a mill located on a tributary of the Pocomoke River. The village of Powellville can be found at the intersection of Mt. Hermon and Powellville roads. Now located in Wicomico County, Powellville used to be part of Worcester County before new boundaries where decided upon.

In 1875, Powellville was home to many businesses, including a saw and grist mill, a carriage and wheelwright shop, a blacksmith, a carpenter, and two large stores. Many other businesses would join these in the following years as Powellville continued to grow. The saw and grist mill exchanged hands a few times starting in the second quarter of the nineteenth century. Robert H. Powell sold the original mill with 300 acres for $4,500 to Joshua Holloway, who later sold it to John. R. Adkins. It was later operated by Elijah Stanton Adkins on the death of his father in 1871.

Today, many of the buildings in the center of Powellville are abandoned and decaying. The only places still operating are the Powellville Volunteer Fire Department, started in 1962, and the Powellville United Methodist Church, where you can still see people filing in for Sunday service.

One of the buildings you can find still standing used to be known as the Powellville Store or Timmons' Store. Built around 1890, it was one of the last to remain an active business. A post office had been located in this building for many years before being abandoned. Another building still standing is the Burbage store, built around 1870 and owned by Sampson Burbage until his death in 1881. From May 1852 till February 1857, Sampson co-owned this property with Joshua Holloway. The second story of this building was used as a meeting room by the Stonewall Council No. 199 of the Junior Order of United American Mechanics.

Every day, I would drive through Powellville, trying to avoid the main highway as much as possible on my way to work. Each time I would think to myself that I should stop and photograph the buildings but never found a reason to actually do so. I found such beauty in this small, quiet village, where it is rare to see a person except maybe the volunteer firefighters washing their firetrucks or someone stopping by to feed the feral cat colony that has taken up home in and around these buildings. Though this town might be just a shadow of its former self, it is now the perfect place for anyone looking for a quiet place to settle down.

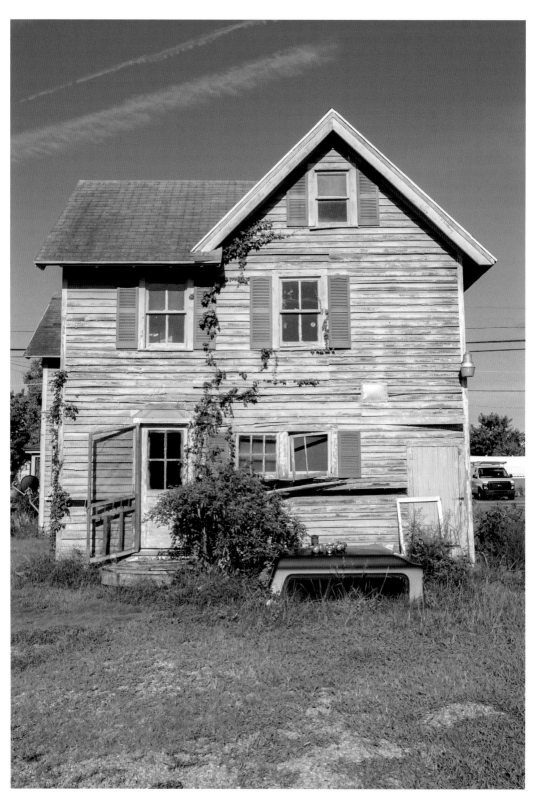

Back of house 5065 in Powellville.

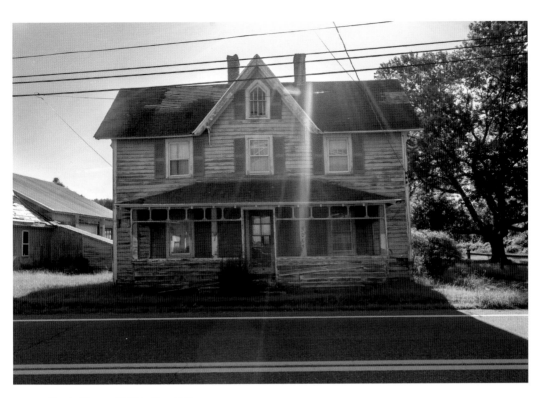

Front of house 5065 in Powellville.

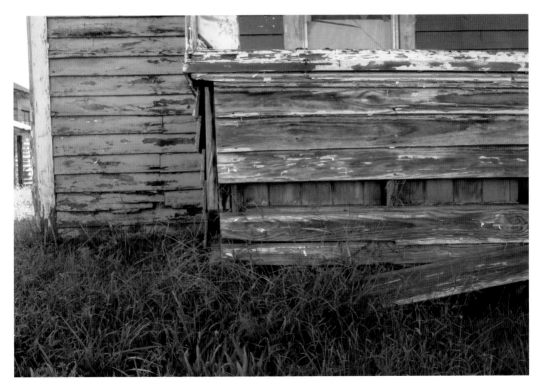

Missing wood siding of house 5065.

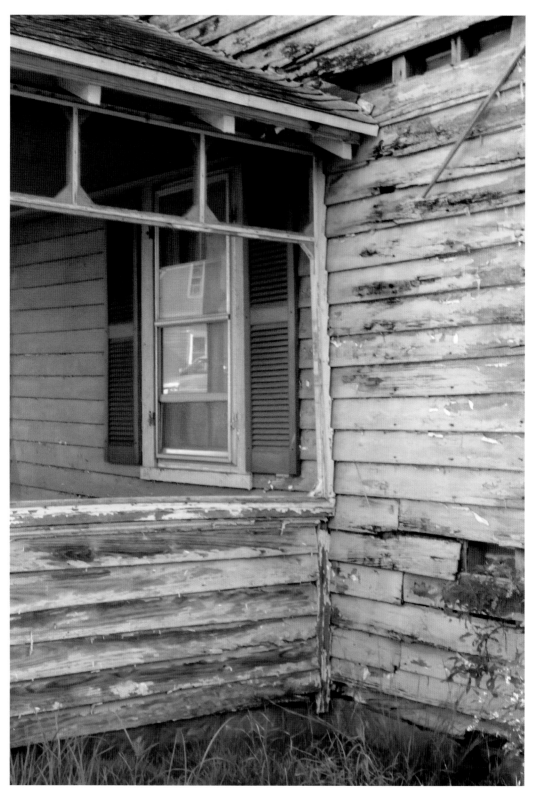

Chipping paint on wood siding.

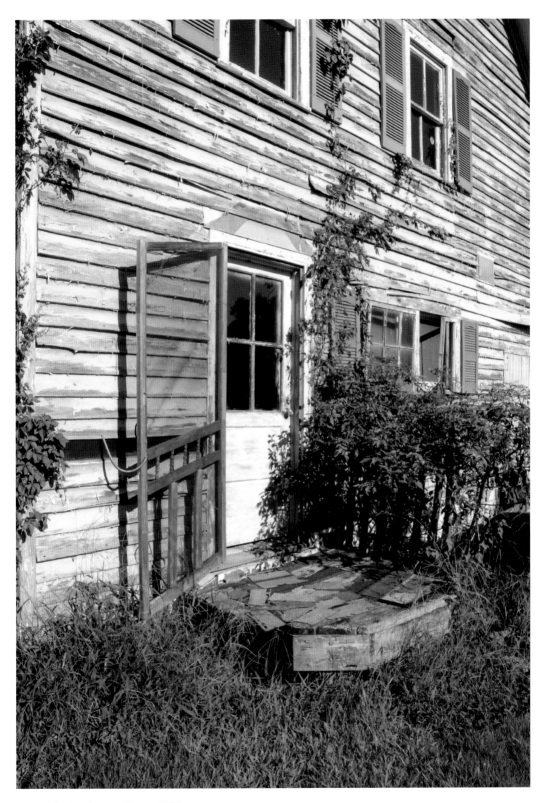

Back entrance of house 5065.

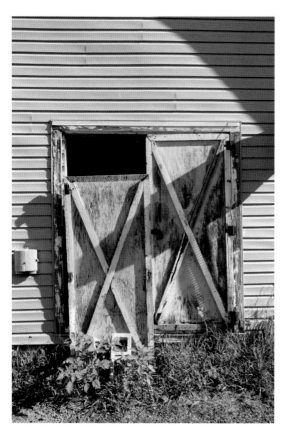

Left: Broken doors on the side of one of the buildings.

Below: Collapsing roof on the side of the old store.

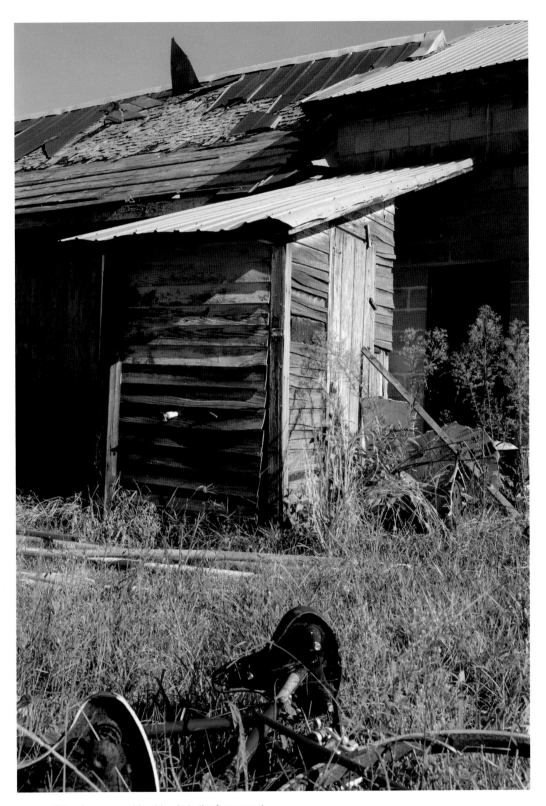

Side of a garage with a bicycle in the foreground.

Rusted spokes of a bicycle lying next to the garage.

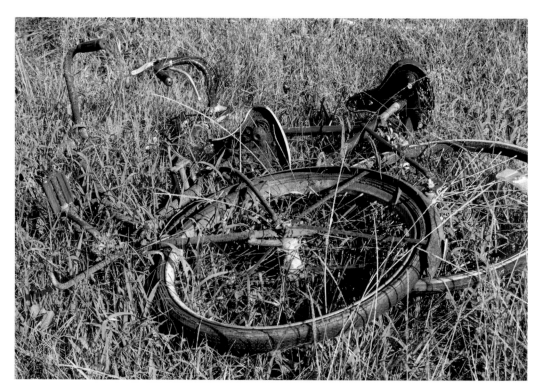

Rusting bicycles in the grass between the garage and house 5065.

Tires piled on the side of the garage.

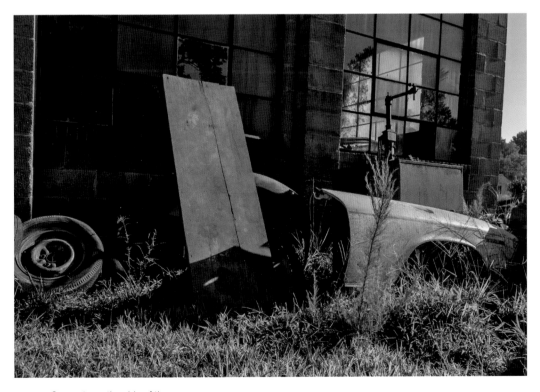

Car parts on the side of the garage.

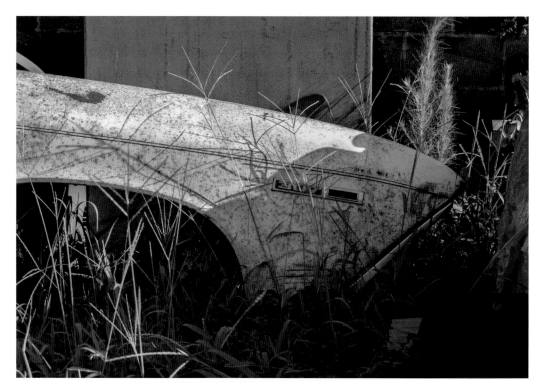

Close up of 307 car part leaned against the garage.

Close up of rusting car part in the grass.

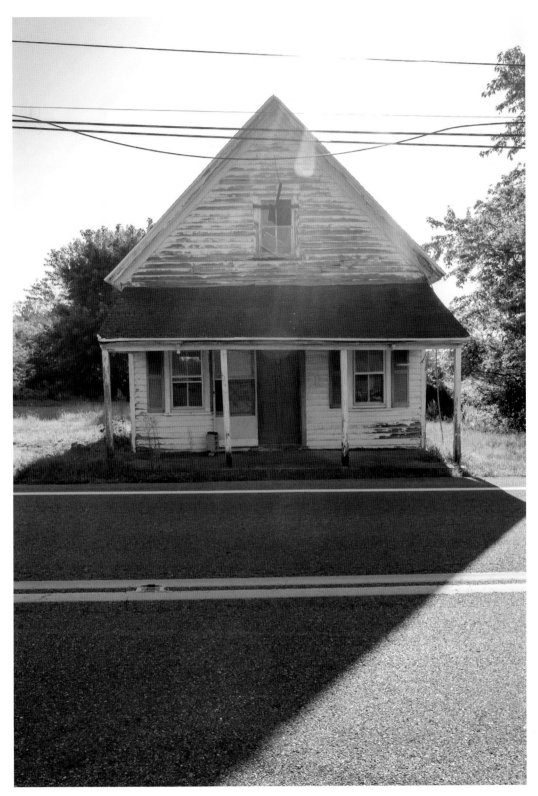

Front of the house in Powellville center.

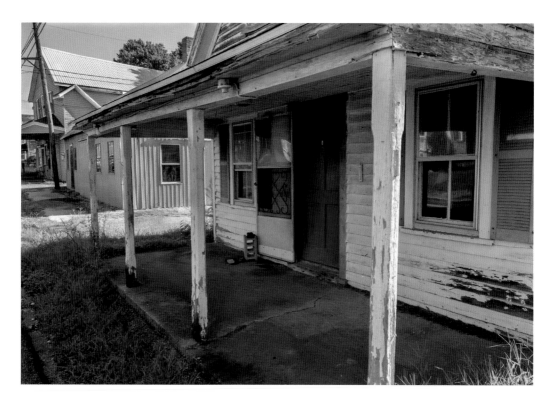

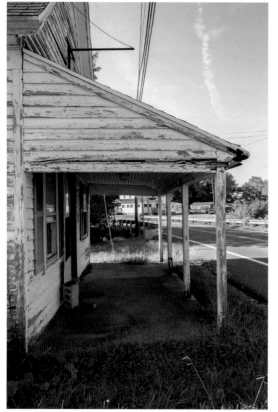

Above: Sidewalk view of abandoned properties.

Left: Side view of the front of the house.

Chair in front of the old post office.

Door to the storage on the side of a house.

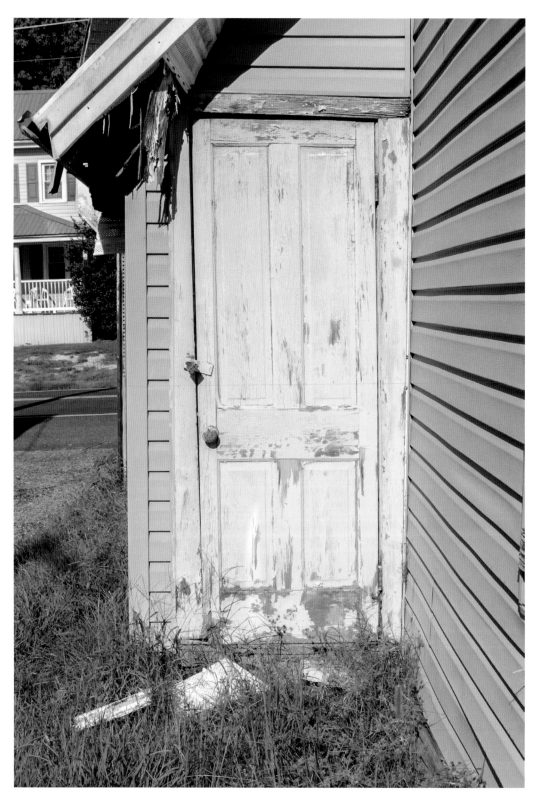

Door to additional storage.

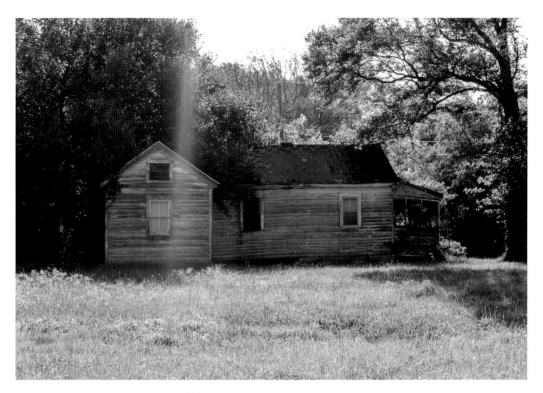

Decaying house behind house 5065.

Ivy growing on the back side of the garage.

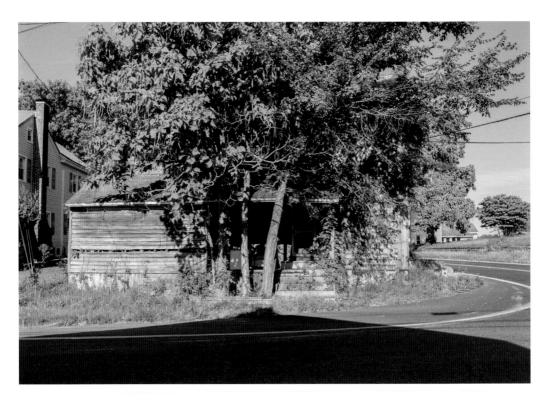

Burbage store side entrance.

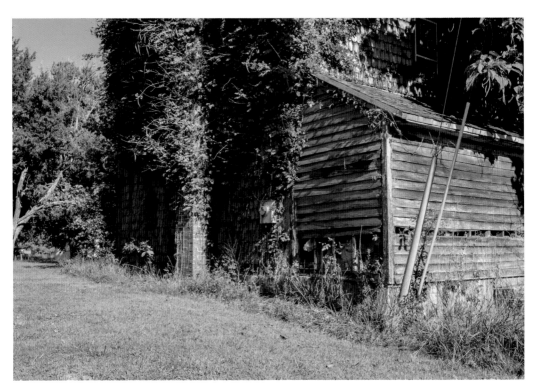

Back side of old Burbage store.

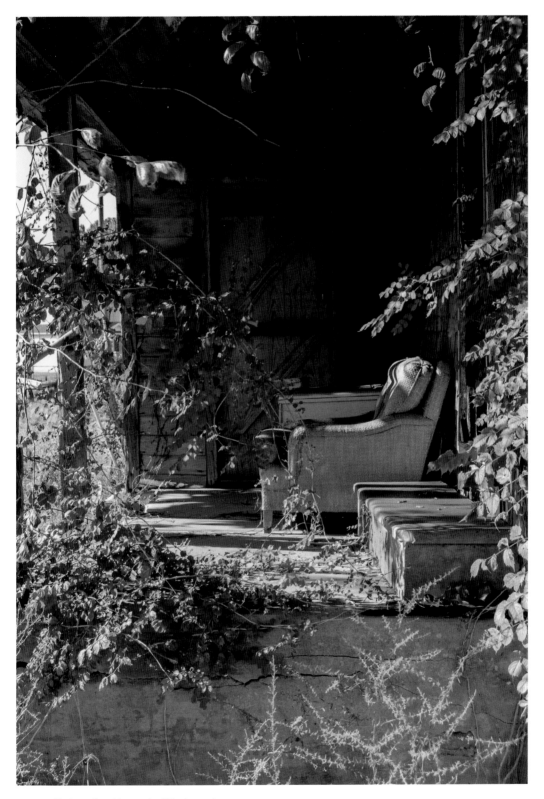

Chair on the side porch of Burbage store.

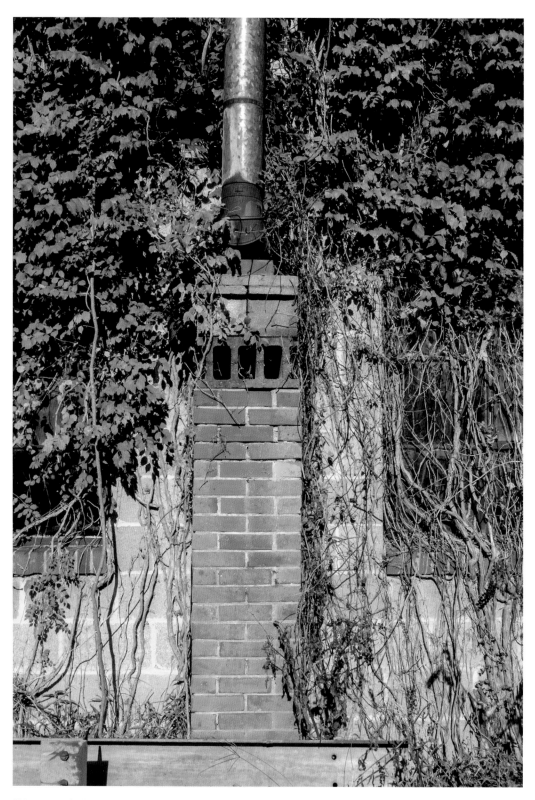

Chimney on the back side of the garage.

Plant overgrowth on the garage door.

Plants taking over broken wood.

Plants overtaking second-floor balcony door of Burbage store.

Broken siding of the house.

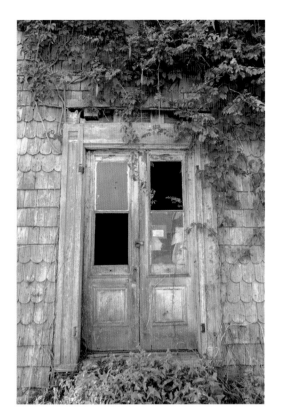

Front door of old Burbage store.

Vines growing up the side of the store.

5

PORTERS CROSSING ROAD

T his is another property you would not find if you went searching for it today. It has been demolished and is currently only used as farmland. I happened upon it at the time photographers like to call the "golden hour." Because of this, I had to shoot very quickly, making sure to get as many photos as possible before the gorgeous light from the setting sun was gone.

There were not as many building as some of the other locations I have photographed, but I was still able to get some beautiful shots. I did not go into the main house, as all the windows were boarded up and it would have been impossible to see anything inside. All the photographs I shot are of the outbuildings, including the barn, chicken house, and silo.

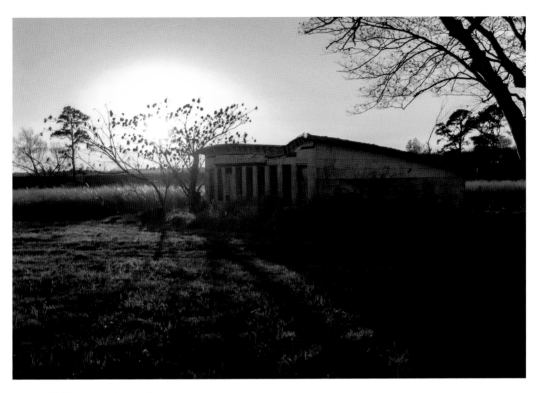

Chicken coop at sunset.

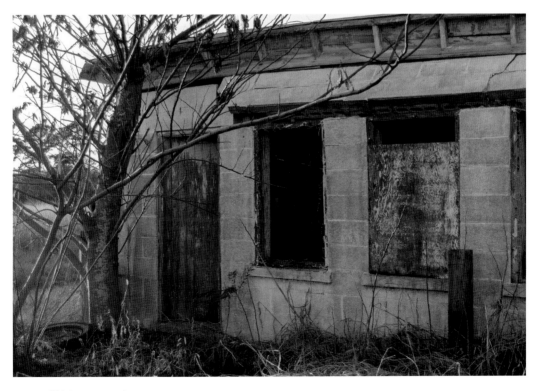

Chicken coop entrance.

Left: Roof shingles of the chicken coop at sunset.

Below: Caved-in roof of the chicken coop.

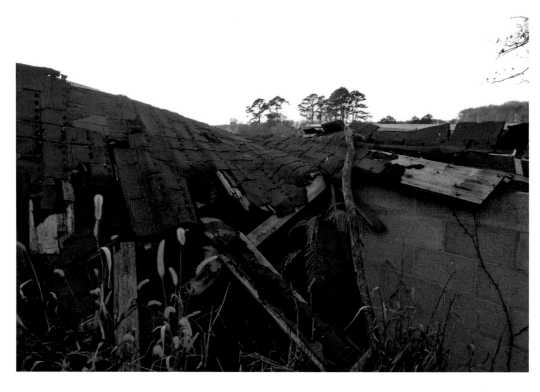

Close up of the fallen roof of the chicken coop.

Pipe on the side of the barn at sunset.

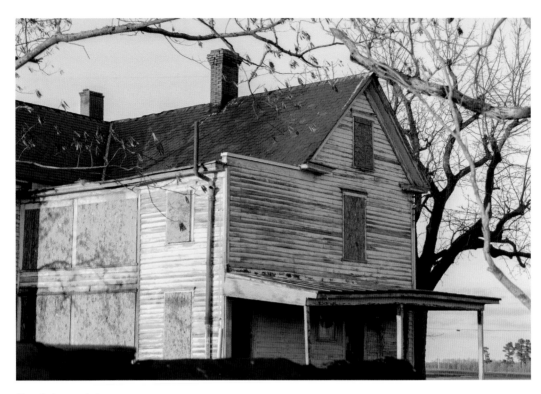

Boarded-up main house.

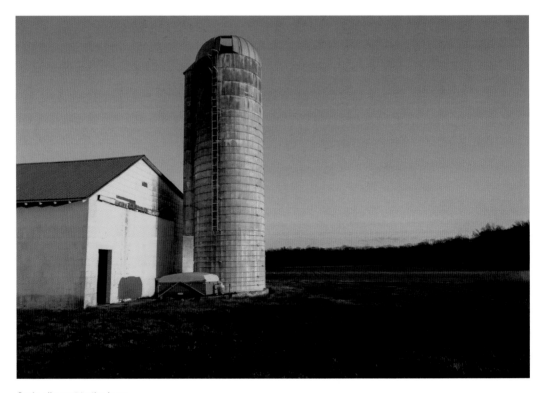

Grain silo next to the barn.

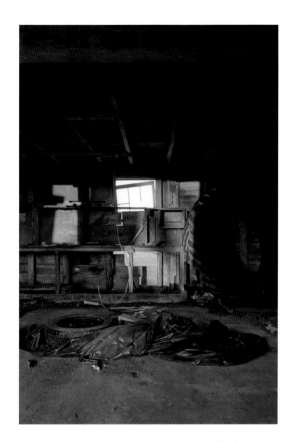

Right: Shed interior at sunset.

Below: Brick on the ground of barn.

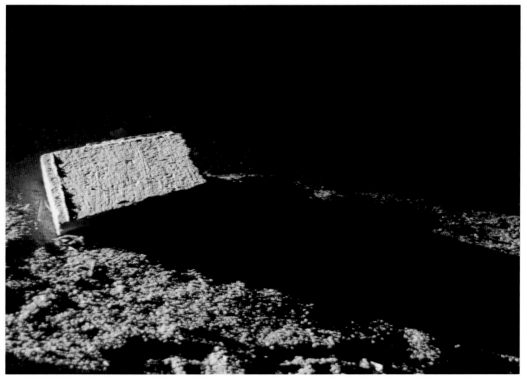

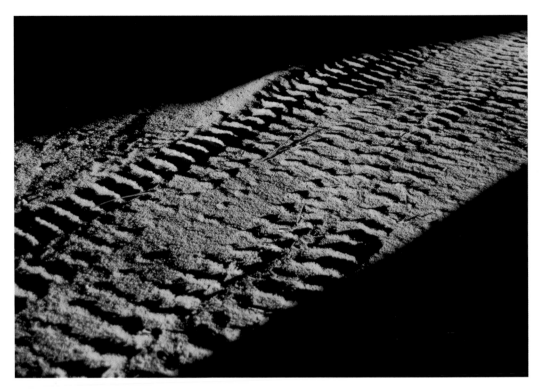

Farm machinery tire tracks on the floor of barn.

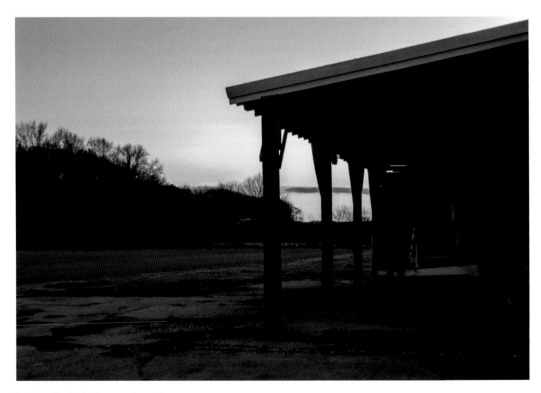

Loafing shed with farm equipment.

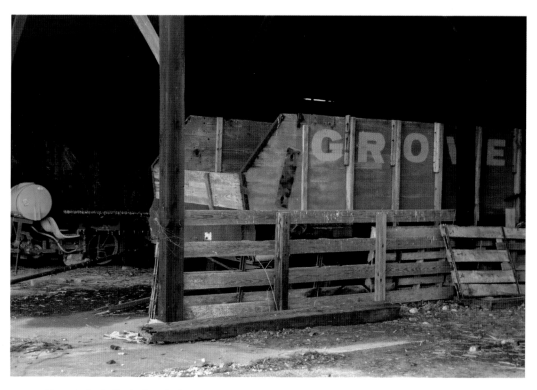

Grove trailer in the loafing shed.

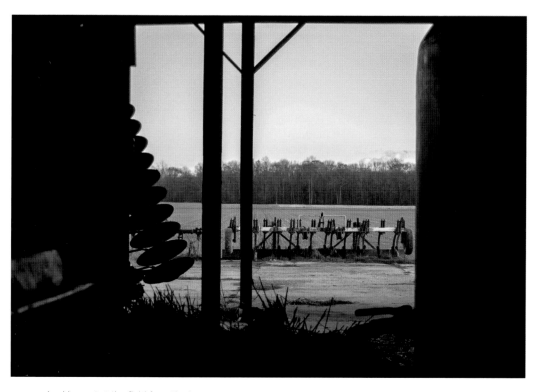

Looking out at the field from the barn.

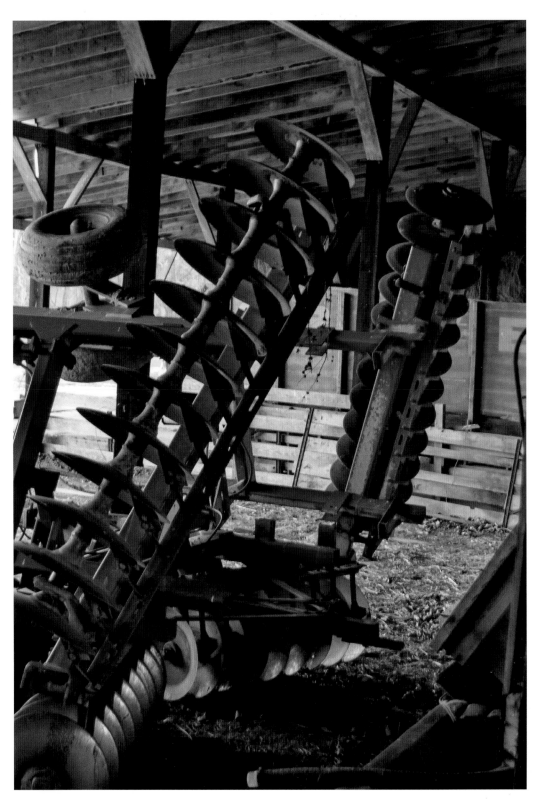

Farming equipment located in the loafing shed.

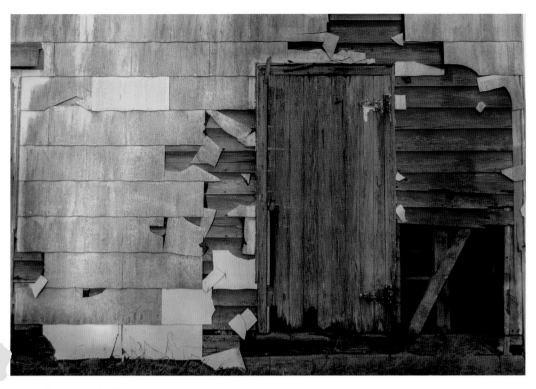

Door to shed with peeling siding.

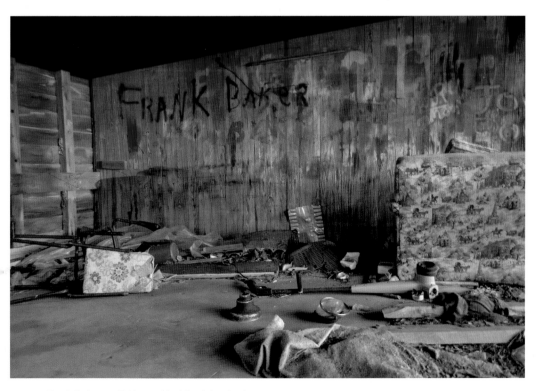

Frank Baker graffiti located inside of the shed.

BIBLIOGRAPHY

Maryland Historical Trust. "Medusa, Maryland's Cultural Resource Information System." Medusa, Maryland's Cultural Resource Information System, Version 1.0, 2016, mht.maryland.gov/secure/Medusa.

"U.S. Census Bureau QuickFacts: Worcester County, Maryland." Census Bureau QuickFacts, www.census.gov/quickfacts/worcestercountymaryland.